CHARLES B. ROGERS

IMAGES OF THE AMERICAN WEST

PAINTINGS AND HAIKU

Celestial Arts
Millbrae, California

0832 999 0001 X2

P9-BHW-467

Copyright © 1975 by Celestial Arts
231 Adrian Road, Millbrae, California 94030

No part of this book may be reproduced by any mechanical, photographic
or electronic process, or in the form of a phonographic recording, nor may
it be stored in a retrieval system, transmitted, or otherwise copied for public
or private use without the written permission of the publisher.

First Printing, January 1975
Made in the United States of America

Library of Congress Cataloging in Publication Data

Rogers, Charles B 1911-
 Images of the American West.

 1. Rogers, Charles B., 1911- 2. Southwest,
New, in art. I. Title.
NX 512.R63A47 759.13 74-25838
ISBN 0-89087-010-1 pbk.

INTRODUCTION

There is the exceptional man who begs no favors of anyone but stands on his own two feet and with his own two hands, his native genius, his strength and drive, wrests a brilliant career for himself from an exacting world, and creates beautiful things for all the world to use and enjoy. Such a man is Charlie Rogers.

Charlie, known generally as "The Kansan," has received over 130 art awards. He is represented in various museums, including the Metropolitan, Boston Public Library, Smithsonian, and the Instituto Norte Americano. He headed the department of Art at Bethany College and was recipient of a Master of Fine Arts Degree from the California College of Arts and Crafts. In 1970, he was honored by the "Native Sons and Daughters of Kansas" and by Governor Robert Docking as the "Kansan of the Year" for his "many achievements in the field of art." February 27, 1970 was celebrated in Ellsworth, Kansas, as "Charles B. Rogers Day."

In the role of painter of the West, Charlie specializes on its life and appearance: Indians, cowpokes, longhorns and herefords, or simply poetic landscapes.

In Ellsworth, he founded, owns, and manages the Rogers Museum-Gallery.

Charlie is also a writer of note and a homespun philosopher along the lines of his famous namesake and counterpart, Will Rogers. The following declaration by Charlie could easily have been written by Will:

> No one can help you with creative work. No one can do it for you. You're on your own, and the individual who can't self-propel is out of luck because he has to do that. There is no other way.

Yes, Charlie is self-propelled. The world needs more of his type.

Frederic Whitaker, N.A.

BIRDS ON THE MOON

The moon's ear is low
 To catch the song of the crickets
On the hill's rough edges.

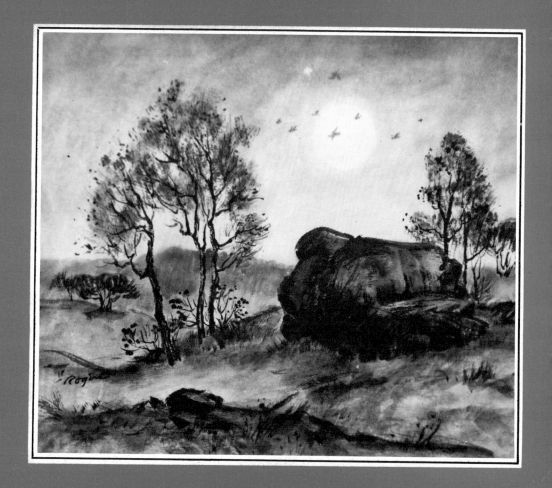

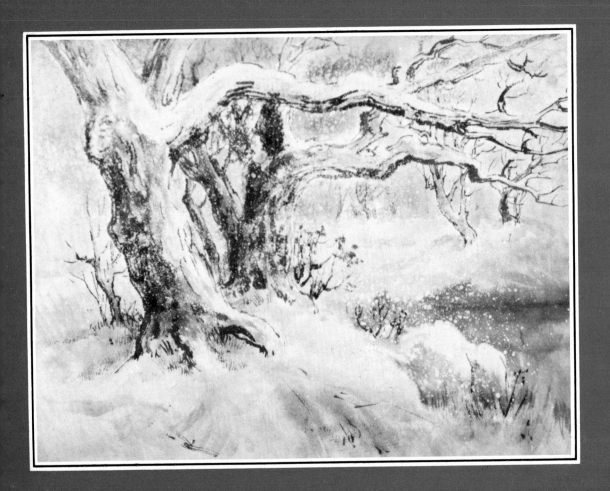

LATE WINTER SNOW

Trees with fingered limbs —
 Reaching through soft silent snow —
Listen for whispers.

HARP OF THE POND

Upright tendrils stand,
 A harp for autumn breezes...
Who hears the sad song?

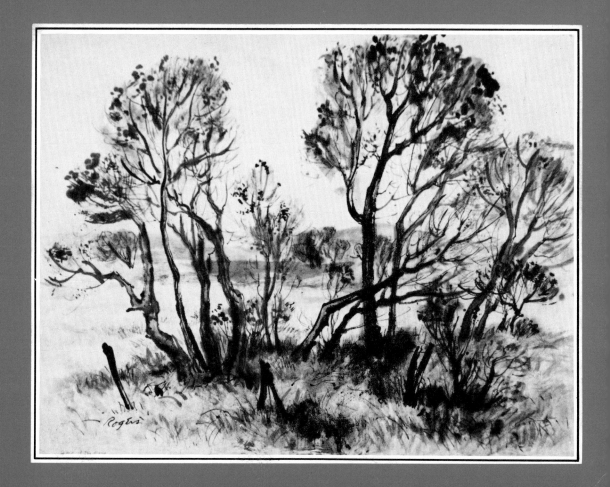

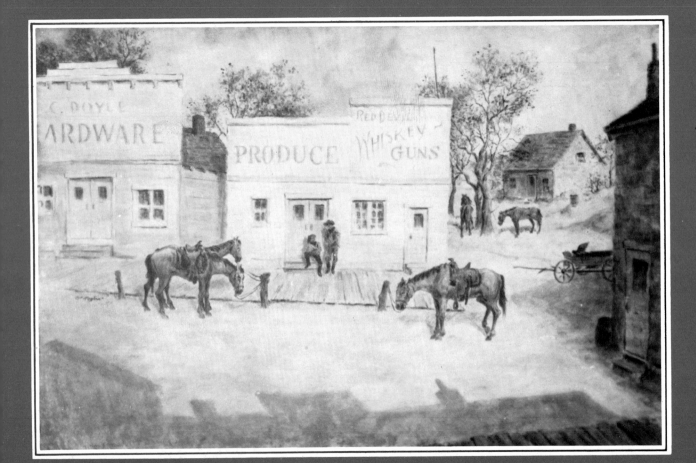

HOUR IN TOWN

An hour of quiet
 With the pall of nothingness
Hanging in the air.

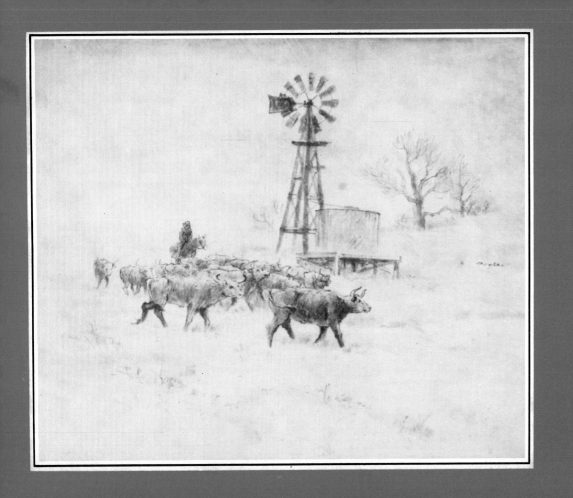

BLIZZARD BREWING

When dancing flakes swirl
 Their eerie, crazy tango . . .
Gather in the stock.

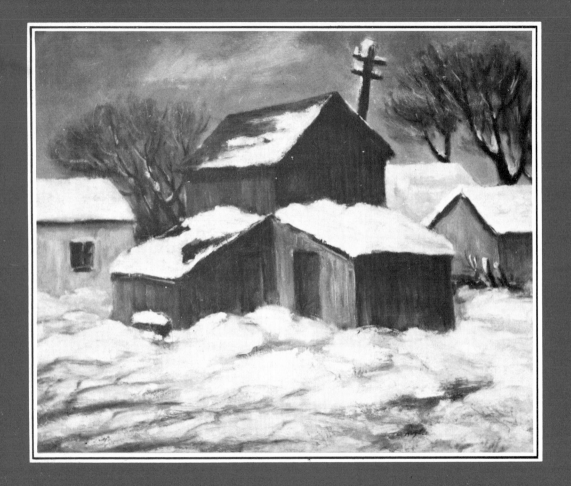

DAY IN JANUARY

Sturdy oxblood barns
 Stand erect in cloak of snow,
Content with winter.

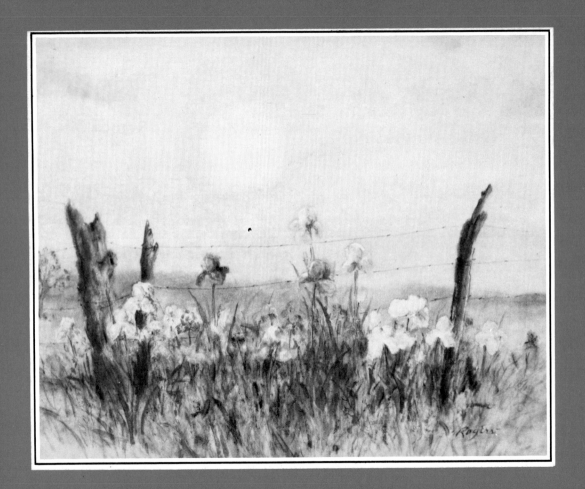

FLAGS BY A BARBED WIRE FENCE

Flags like butterflies
 Waving at a new-born moon
Through the barbed wire fence.

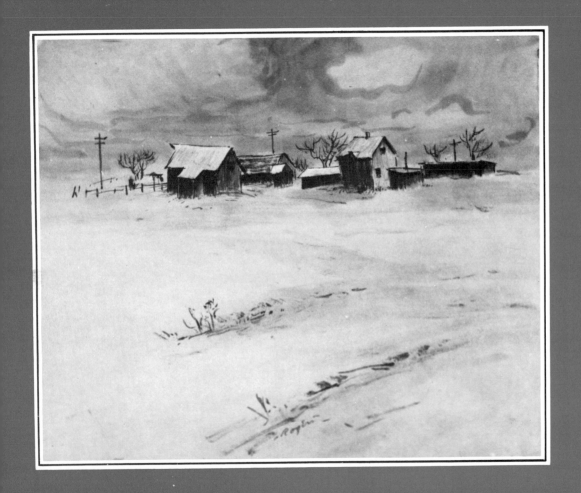

FARM IN WINTER

Don't despoil the snow
 With tracks that lead to nowhere
Warmth of home is near.

19

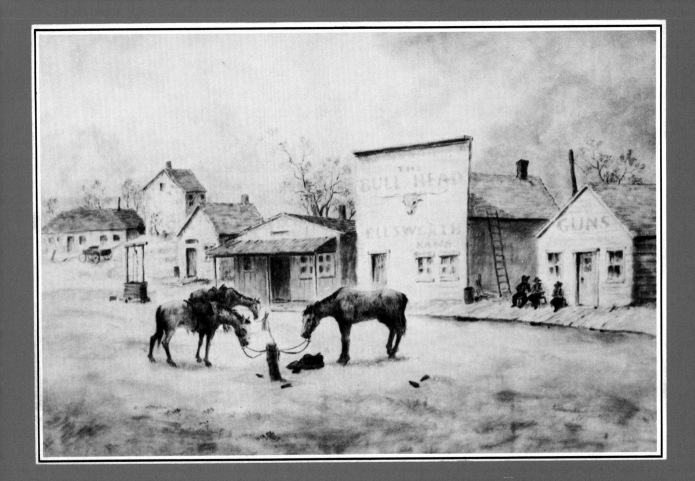

WAITING COW PONIES

Heavy hangs the air,
 Lazy in the bright sunlight
Of a far west town.

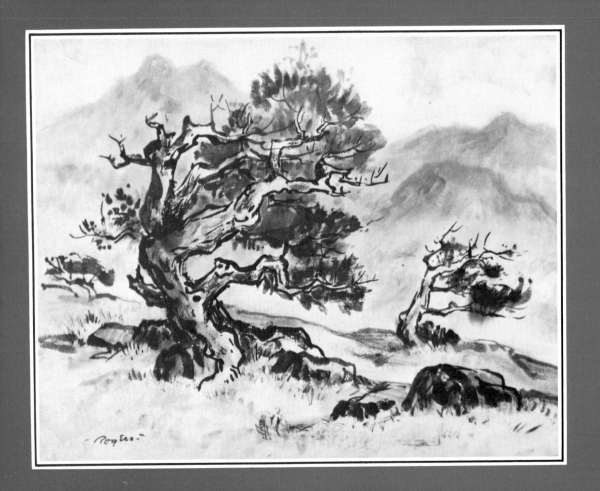

SHAPED BY THE WINDS

Land of whipping winds,
 Demeaning each growing thing...
Can there be no compromise?

MORNING AT THE POND

Listen to the strain,
 More softly than the still pond. . . .
A whispering leaf.

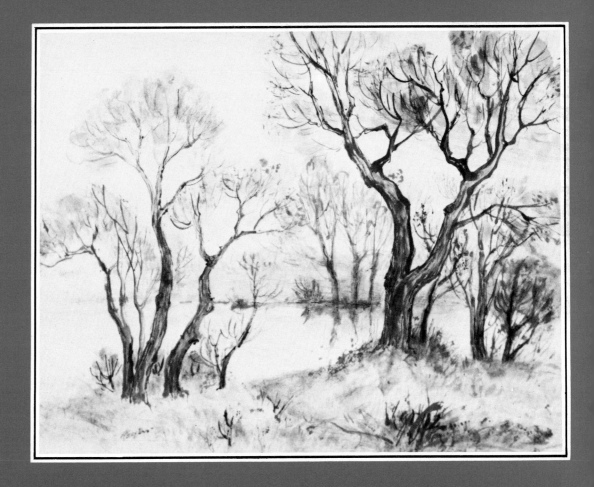

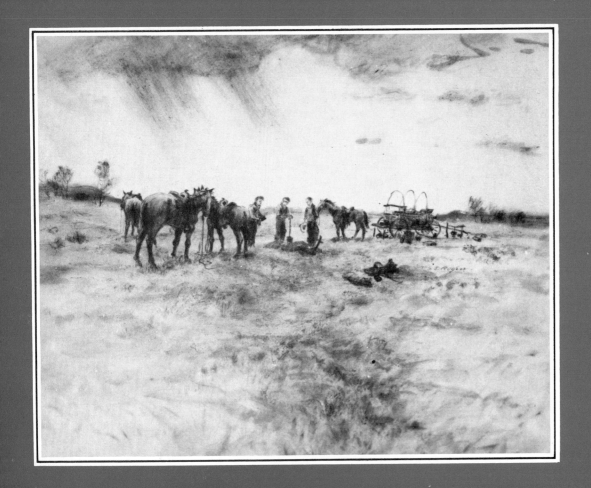

ONE SPRING DAY

After the plantings,
 Cold, lugubrious showers
Bring summer flowers.

27

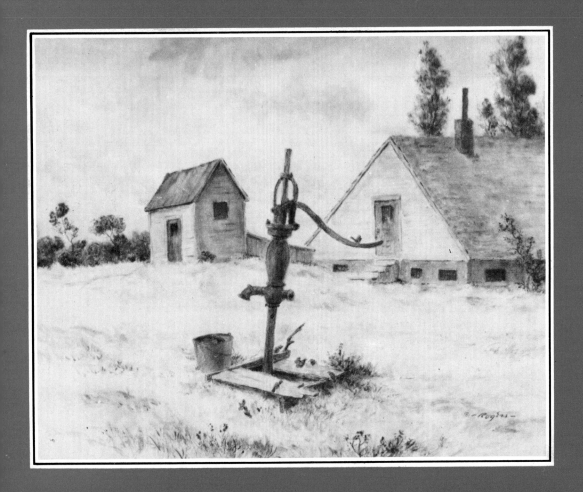

FIGHTING STALLIONS

Glaze-eyed stallions snort
 Their slashing vicious challenge
As musk wafts the air.

31

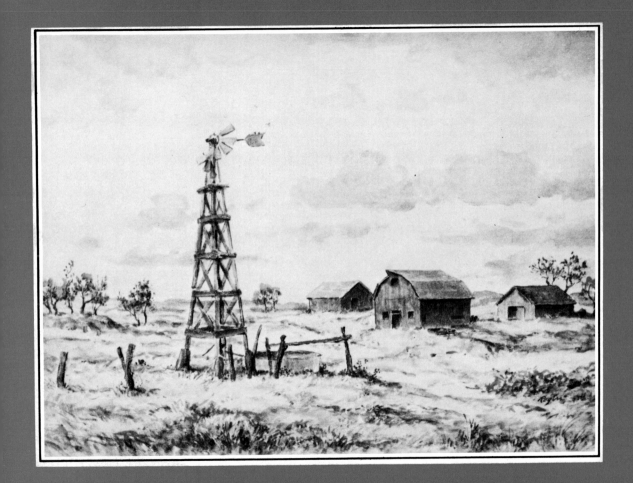

ANCIENT WINDMILL

Tormented windmill
 Wobbling on your wooden legs . . .
Do you remember?

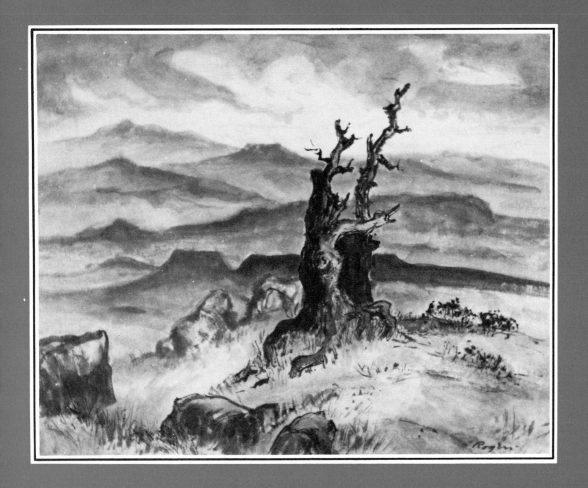

BEYOND THE WILDERNESS

Lonely barren trees
 on a rugged, nameless crest . . .
What is your motive?

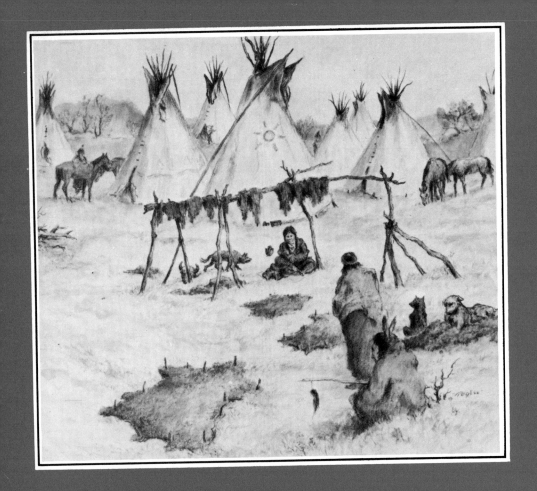

AFTER THE HUNT

Hides and jerky dried,
 Haunted by the swift "God-Dogs"
on this tomorrow.

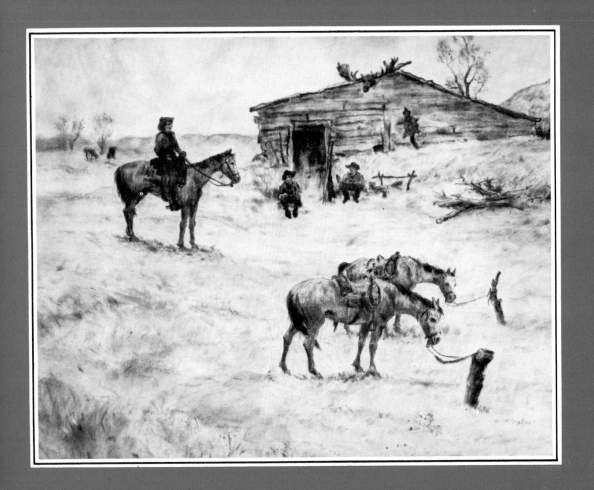

HOME ON THE RANGE [LINE CAMP]

Man's humble hovel
 Beyond the farthest line fence
Serves well the roundup.

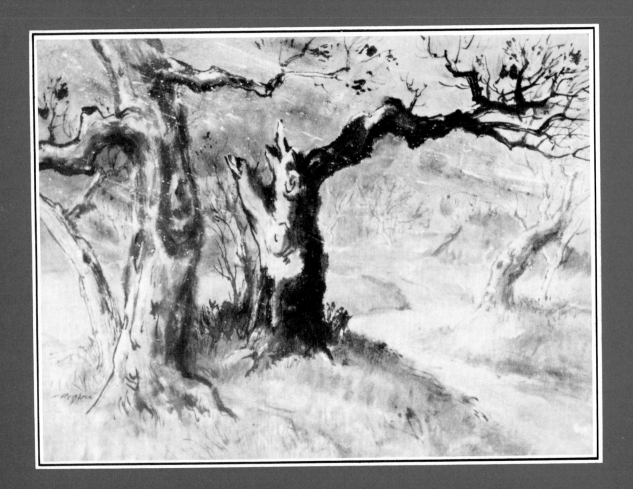

PRELUDE TO WINTER

Does the north wind know
 When it lashes in fury
Its breath causes pain?

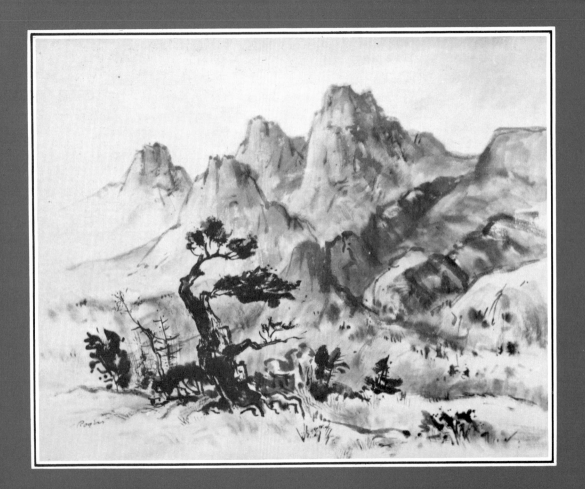

ROCKY PINNACLES

Great mountain peaks
 Reach to sew the gaping sky
With huge needles.

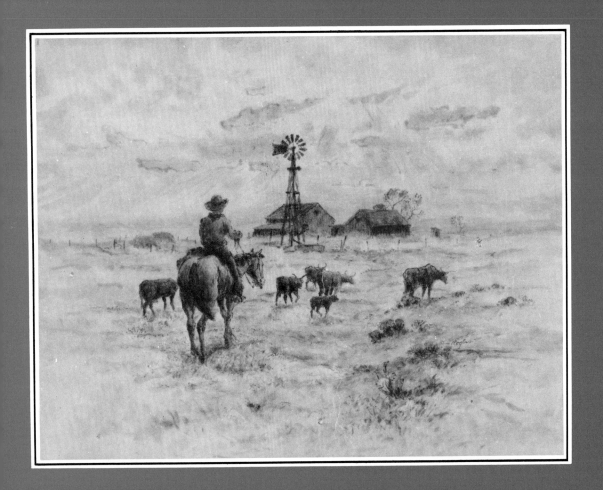

BRINGING IN THE STRAYS

A day of scrounging
 In the arid mesquite hills
Will change a cow's mind.

SPRING IN THE WEST

Pink cumulus clouds
 Rise high in a purple sky
To warn of night storms.

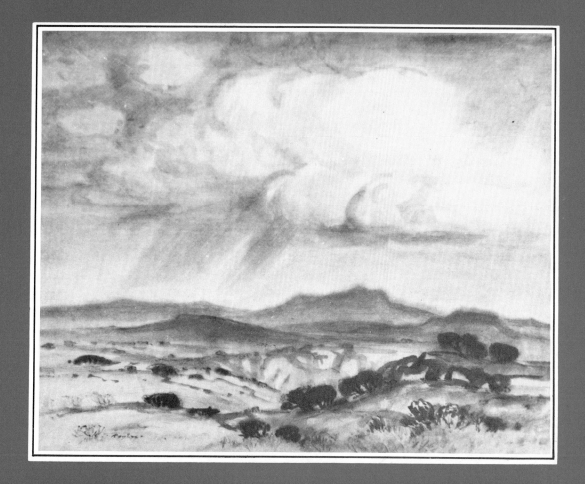

QUIET HOUR

One still soft moment
 And a dream of times gone by
As the longhorns graze.

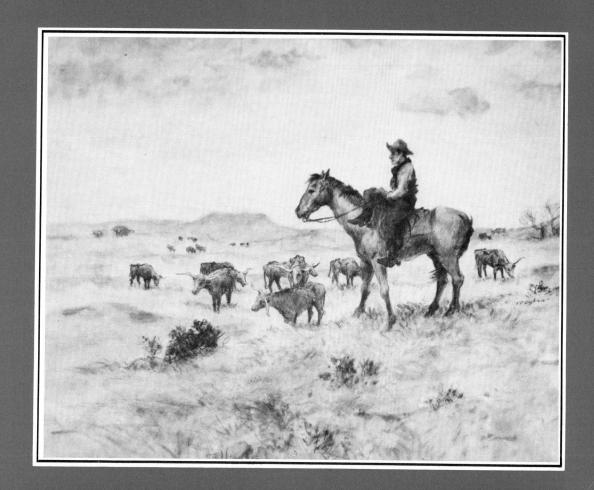

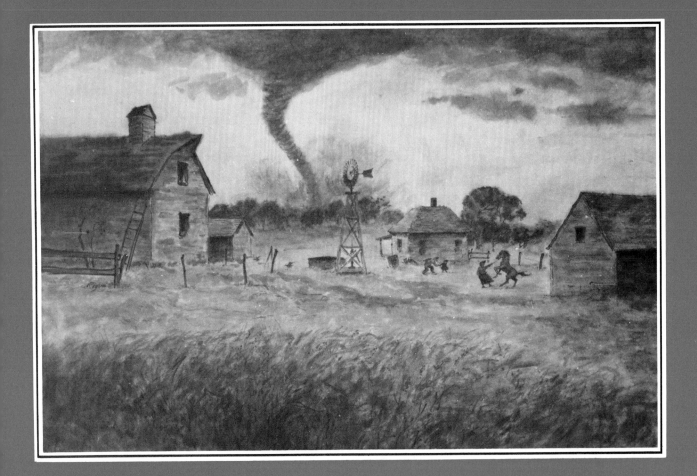

HORN OF PLENTY

Roaring, snarling snout
 From dense, lugubrious skies...
Change your angry course.

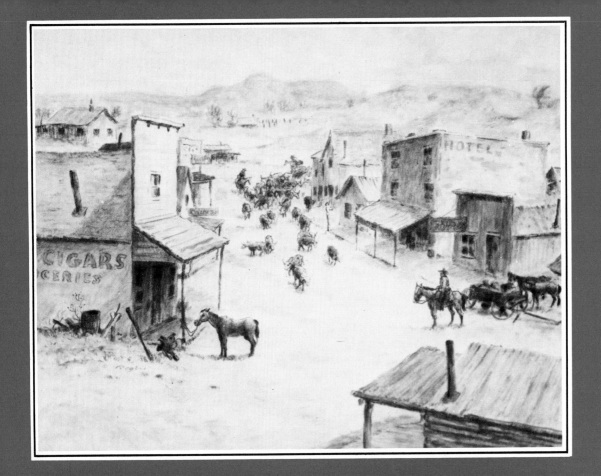

DOWN MAINSTREET

Puny buildings grin
 At herds of driven cattle
As the stock pens wait.

NEW MOON AND CATTLE CHUTES

Silvered crescent moon,
 A thing to hang one's dreams on . . .
Welcome to the night.

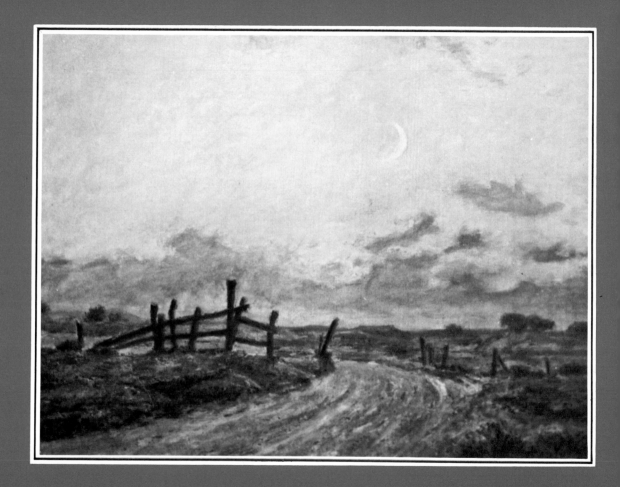

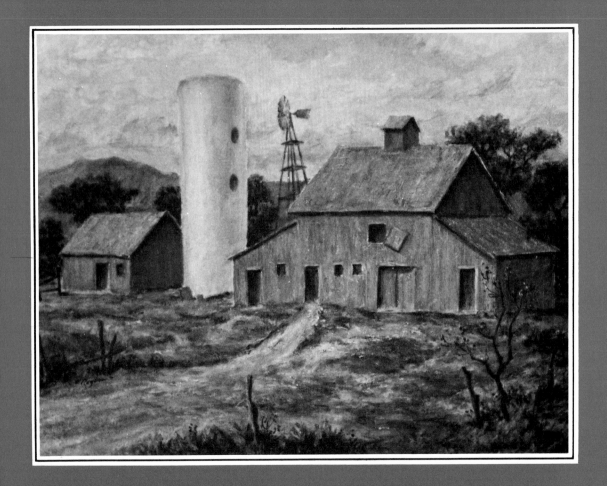

BAT WINGED BARN

They stare nonseeing
　　　These multishaped and wide eyes
Stuck on bleach-blood barns.

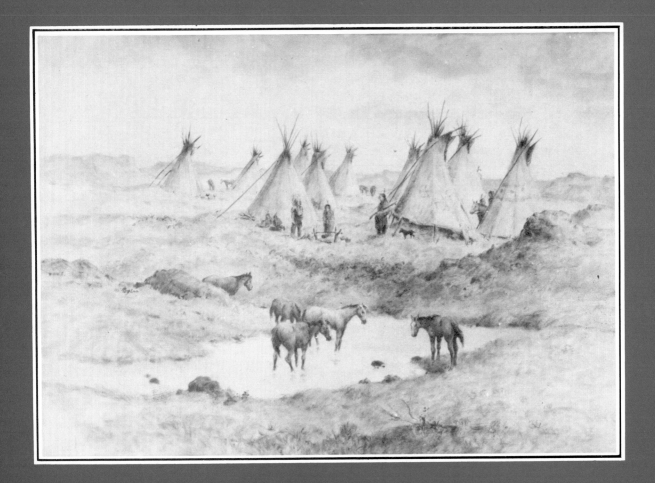

INDIAN CAMP

Red man's earthy life,
 Simple in its rustic wealth,
Was God's better choice.

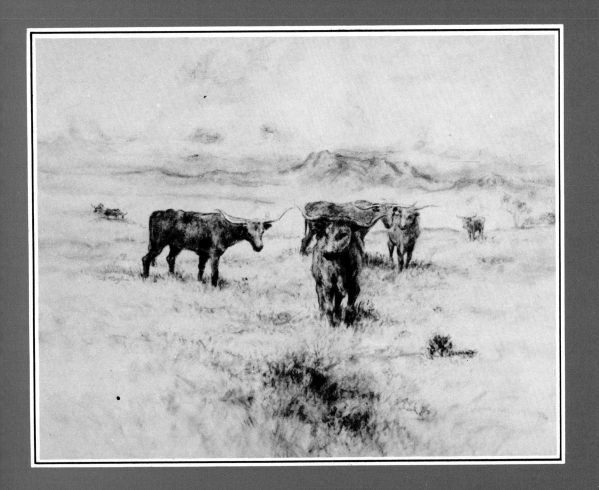

KINGS OF THE TALL GRASS

Historic longhorns,
 You've not a vanquished spirit;
Stand tall in your pride.

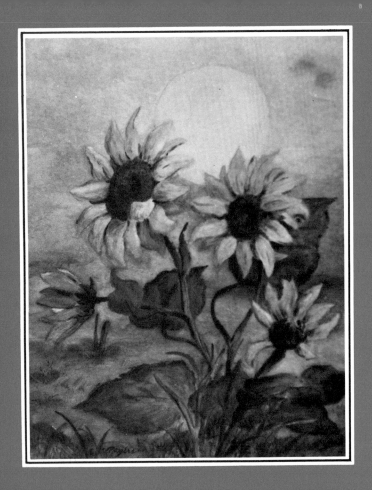

SUNFLOWERS AT MOONRISE

The rich moon may smile,
 But sunflowers cast their brown eyes
To the drying sun.

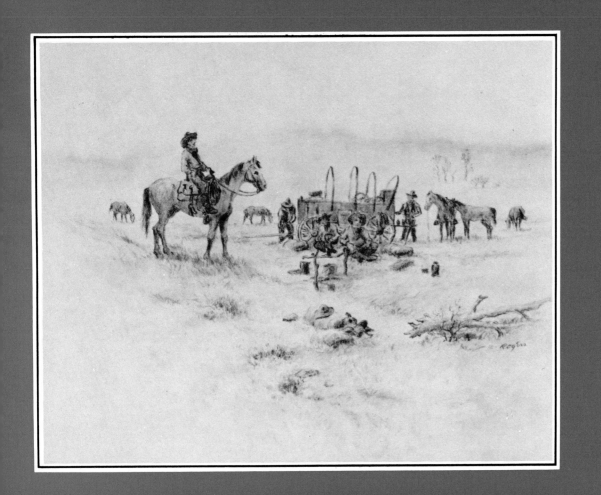

STAKING OUT FOR ROUNDUP

An hour's leisure now;
 Come the morrow, heat the brand
For the fall roundup.

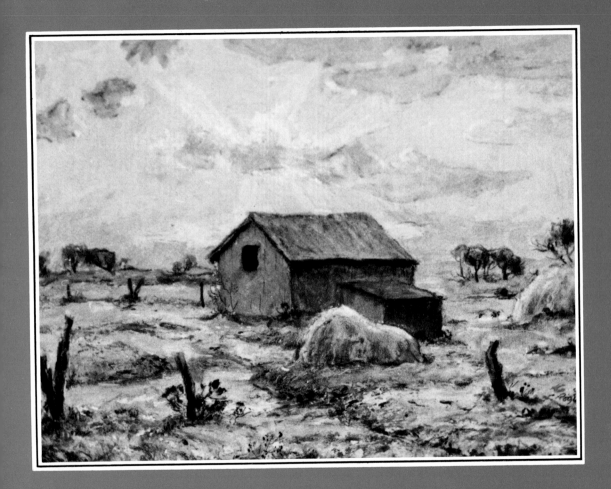

SUNRAYS ON THE FARM

Lazy parting clouds
 Bare the steely eye of God
In autumn's watching.

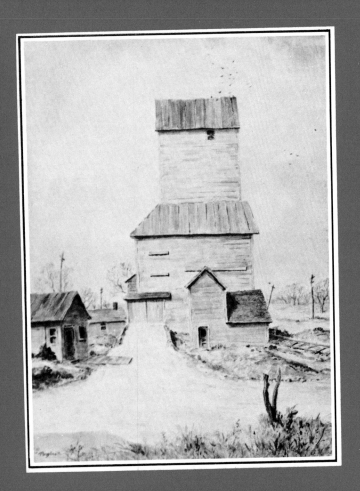

WHEAT LAND ARCHITECTURE

Red elevator
 Serving only pigeon's perch
This lazy summer.

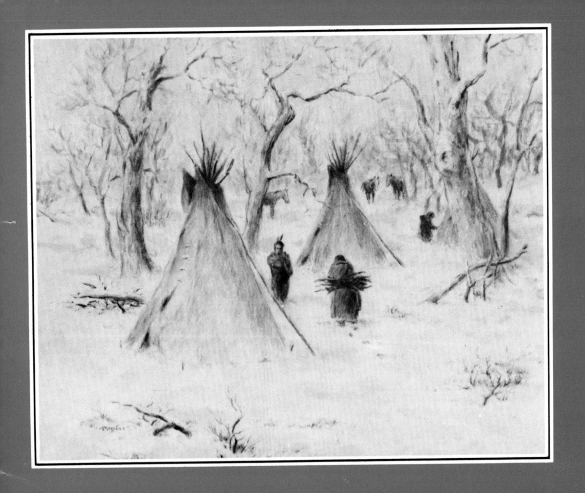

DEAD OF WINTER

Crisp the crunching snow . . .
 Stark the Redman's winter day
Before his dead night.

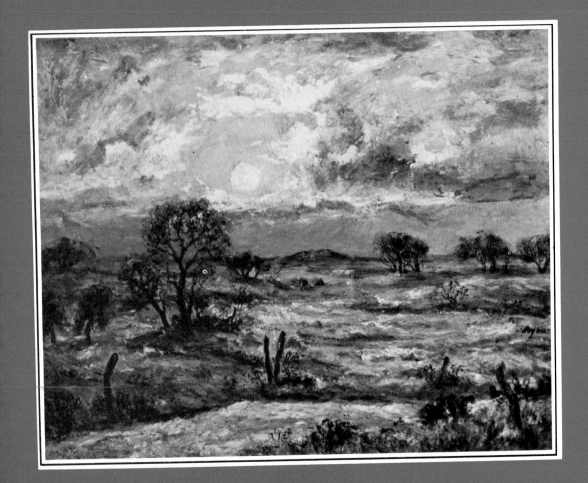

SINKING SILVERY SUN

Laughing as he sinks,
 The optimistic sun knows
Death is for others.

OAK BY THE RED BARN

Ancient gnarled remnants,
 Wherefore those bare bleaching bones...
Inevitable?

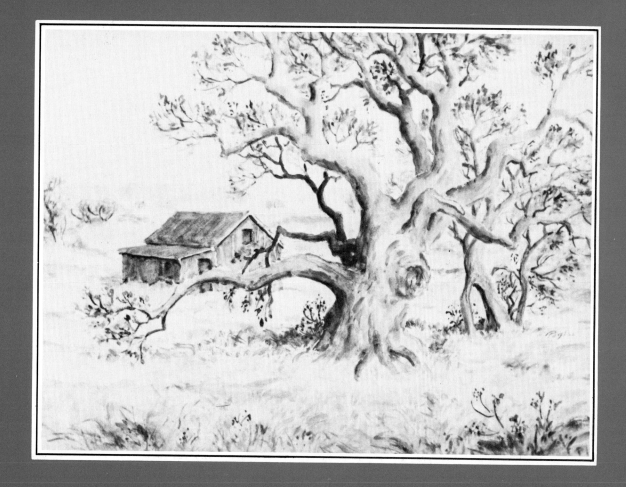

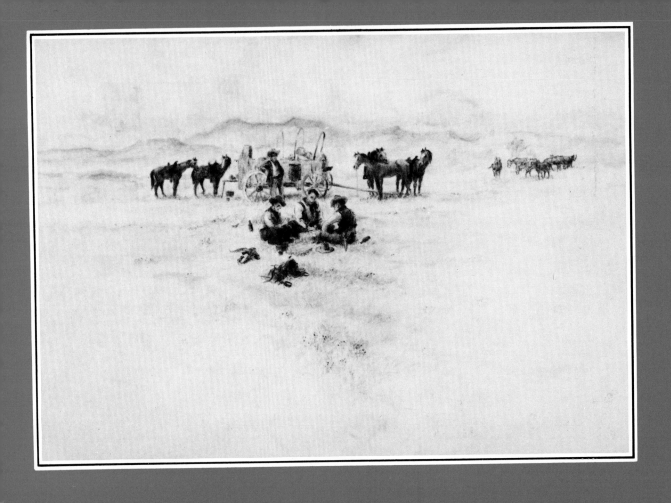

THE FRIENDLY GAME

One leisured moment
 Before the morrow's sweating
Through dusty branding.

THE HIGHEST PINES

Nude and misshapen,
 Whipped by vilest northwest winds . . .
Still they flaunt their pride.

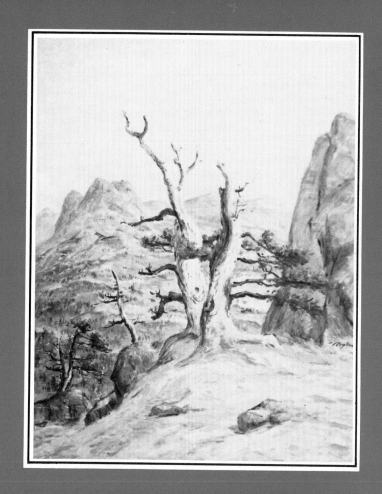

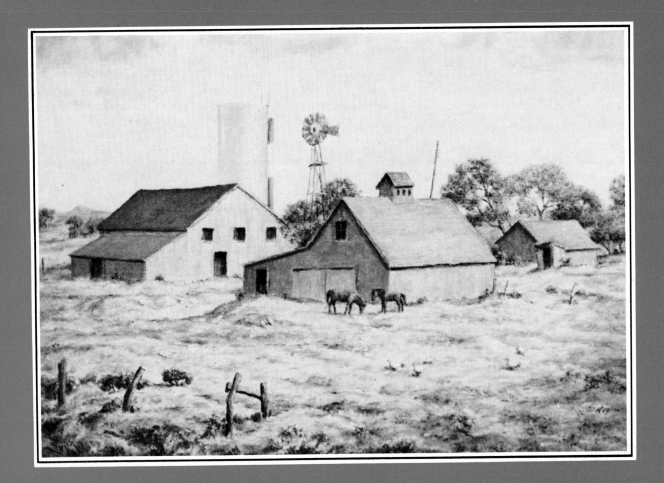

FARMYARD IN MAY

Brightly glows the farm
 With its munching horses
And clucking leghorns.

MORNING SUNDOG

Sun's colored halo
 Swimming in a misty cloud
With moments numbered.

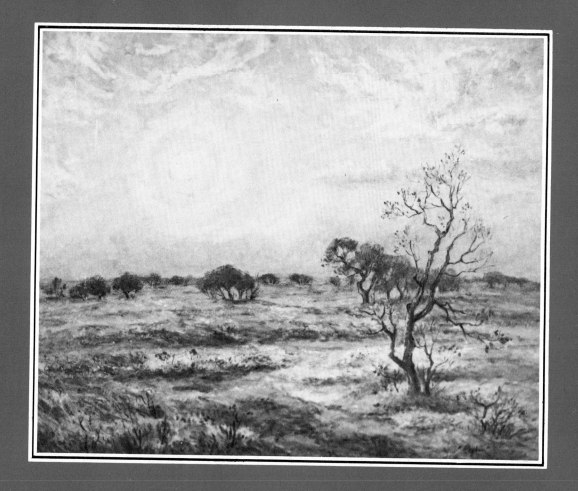

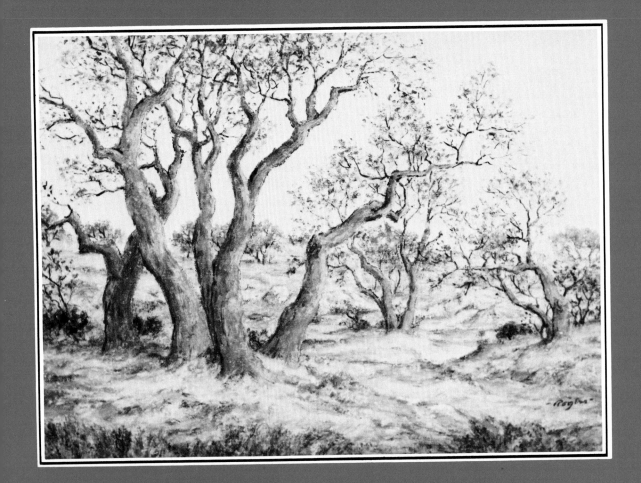

DANCING LEAVES

Last dancing brown leaves...
 The winds will whip you away
Before the next moon.

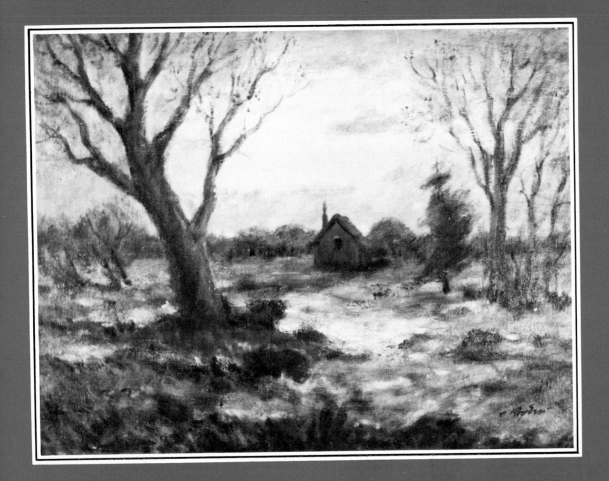

EARLY WINTER MOON

Stark bright winter moon
 Glaze each edge of tufted snow
To please the hoot owls.

WINDHEWN JUNIPER

Trees of sculpturing winds
 Lean leaward in their pain-rack,
Gloried with rhythms.

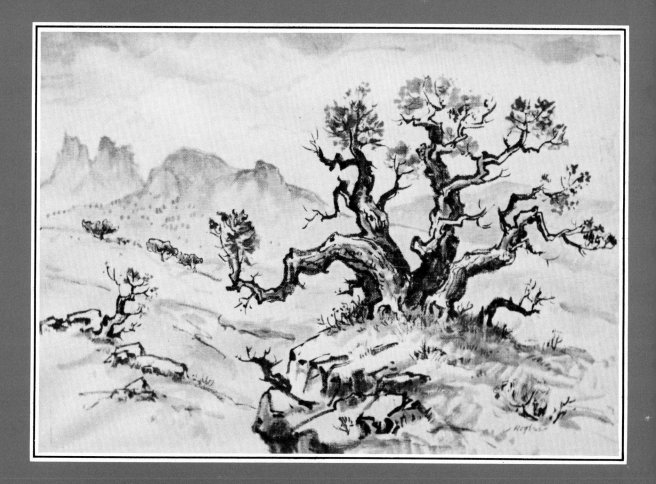

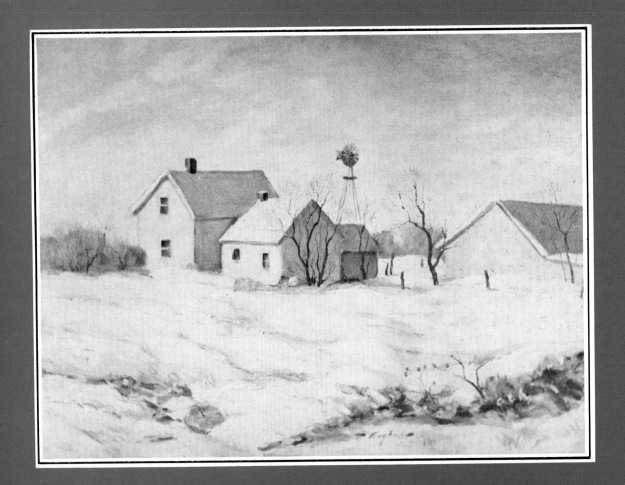

WINTER DAY IN MID-JANUARY

Winter's brightest day
 Takes one moment to herald
The coming of spring,

91

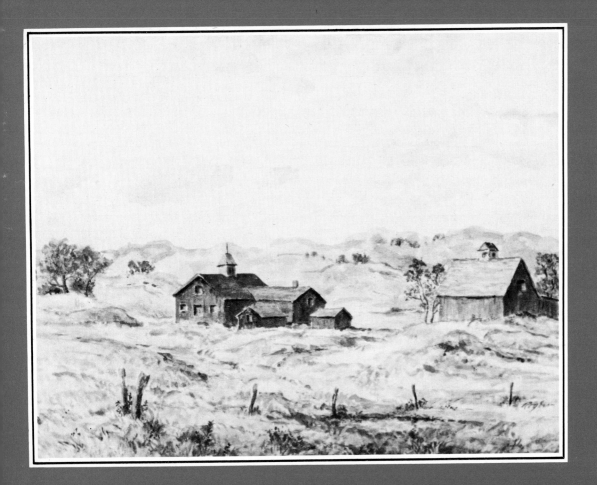

COUNTRY PLACE

Gentle pointing barns
 Sit in comfort on God's turf
And smile at the skies.

WAR PARTY

Stoic and silent men;
 Man and mount in unison
Will face the long sleep.

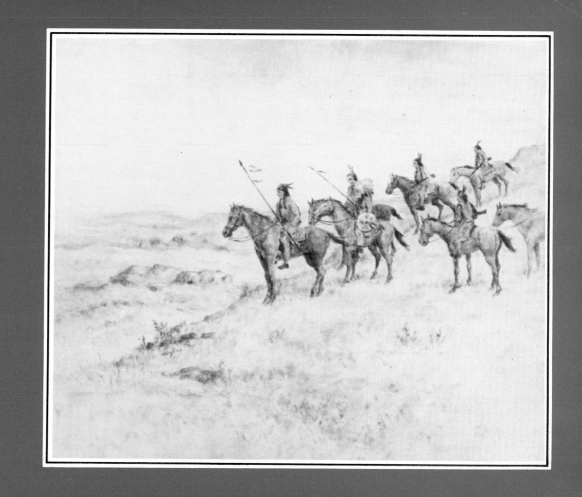

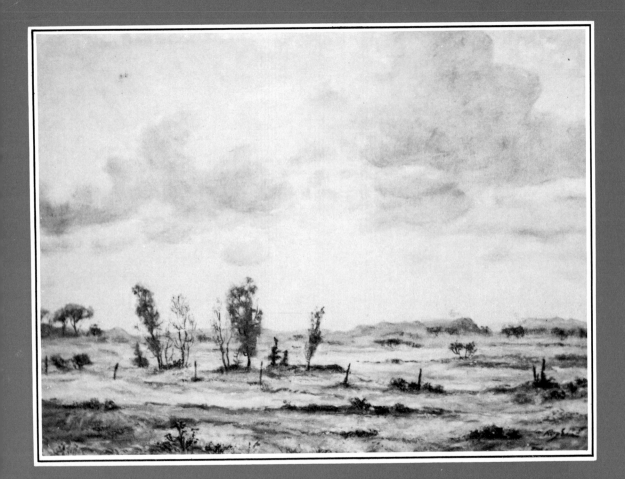

GOLDEN EVENING

The sky a golden sheen
 As the sun slides relentlessly
To die another day.

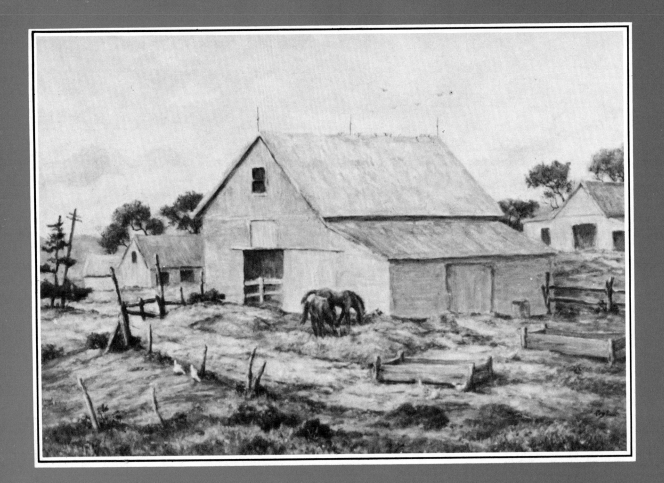

BARN AND CORRAL

Barns with blistered paint
 Hover over clucking hens
In the fenced corral.

MUSHROOM ROCKS

Solid rock and tree
 Spread their varied elements
Toward the heavens.

100

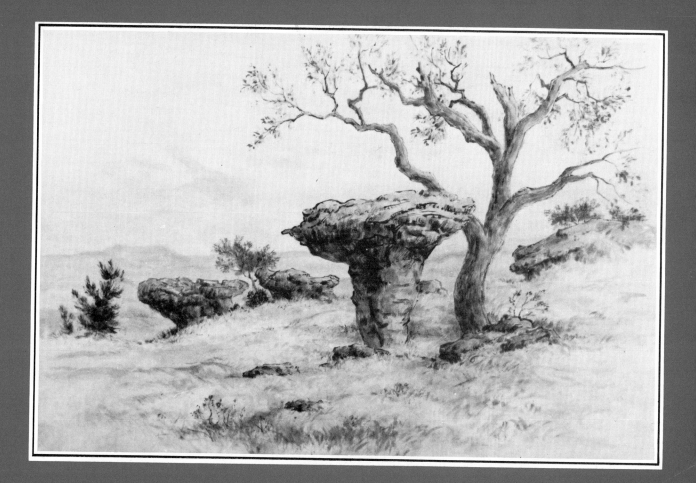

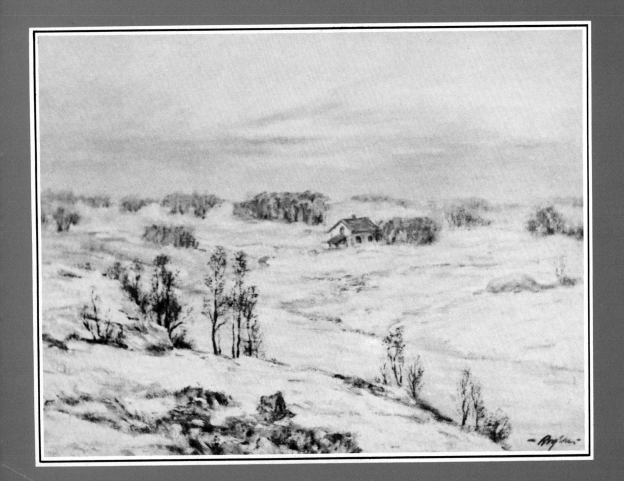

WINTER IN THE VALLEY

Winter's icy glare
 Dancing on the river's banks
Wearing hairy trees.

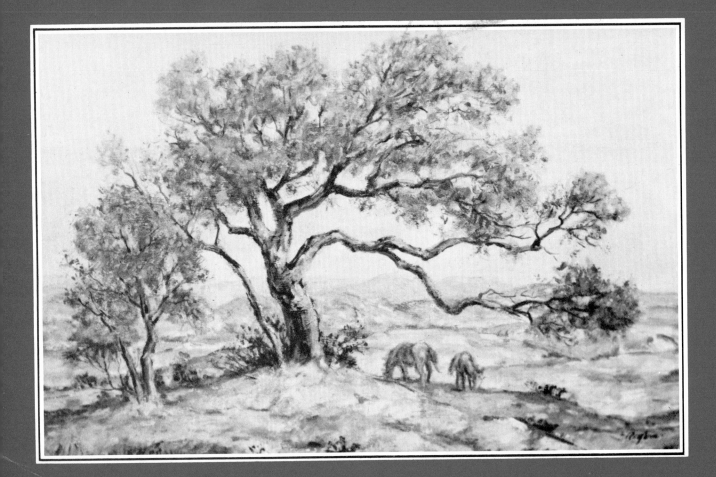

PLEASANT AUTUMN

Horses grazing 'neath
 A tree of autumn, laden
Yellow-red with gold.

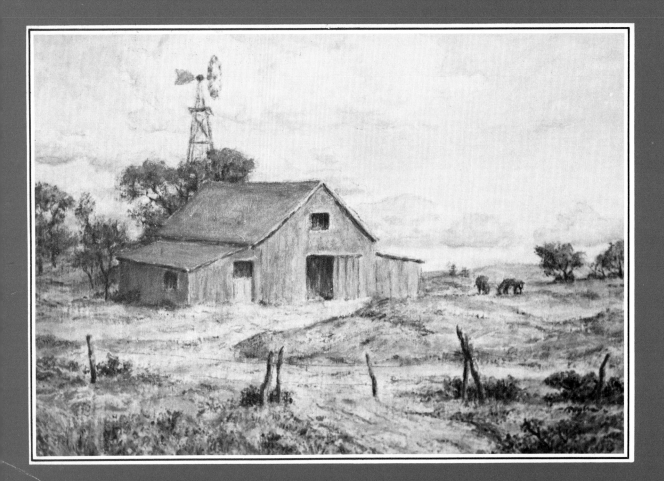

QUIET DAY ON THE PLAINS

Windmill standing stoic,
 The proud red barn is gaping
At the still-borne clouds.

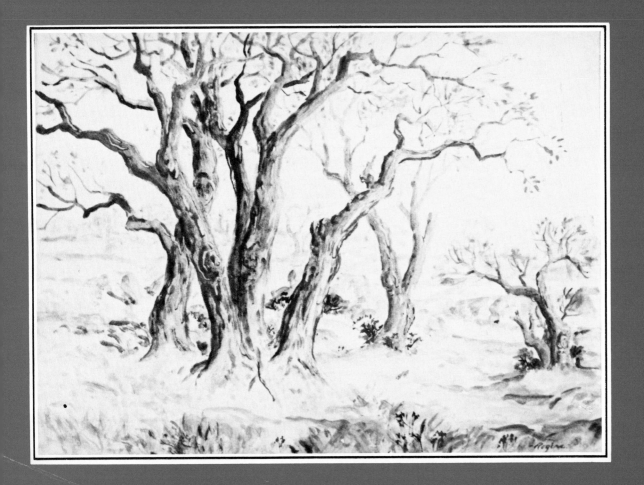

REACHING ELMS

One is not alone
 On a ridge where elm trees
Hold their peace with God.

DESERTED SCHOOLHOUSE

Deserted schoolhouse
 Standing in forgotteness...
What was your purpose?

 o

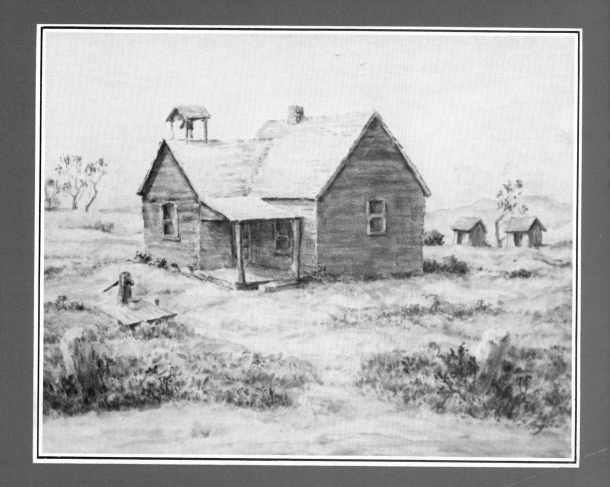

QUIET AT ANCHOR

Quiet drifts the boat
 Bare in lonely solitude,
Awaiting a breeze.

112

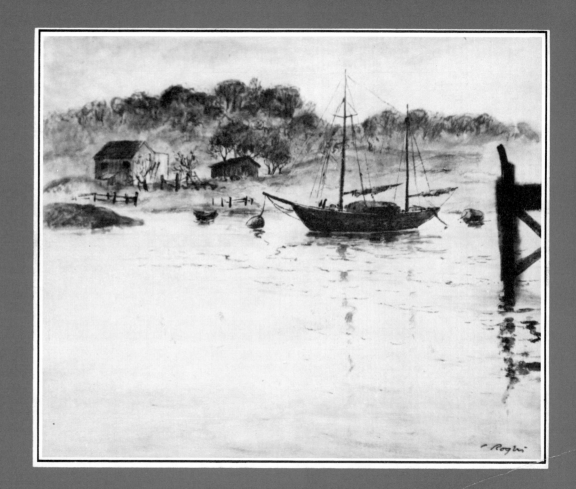

LONGHORNS ON THE RIDGE

Longhorns on the ridge
 Moving slow in skeptic pace
Toward the railhead.

114

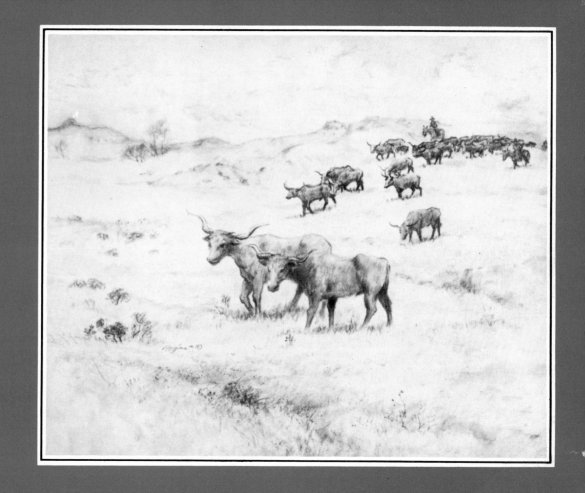

TWO ANCIENT TREES

Stalwart trees are bent,
 Broken by the fiercer winds...
But does the wind know?

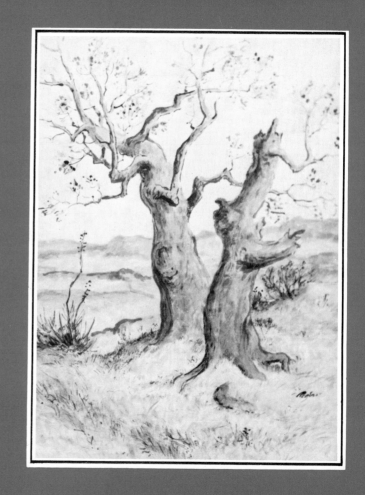

MOON AT THE CANYON LAKE

Lake of emerald,
 Setting for a perfect pearl
On a glazed surface.

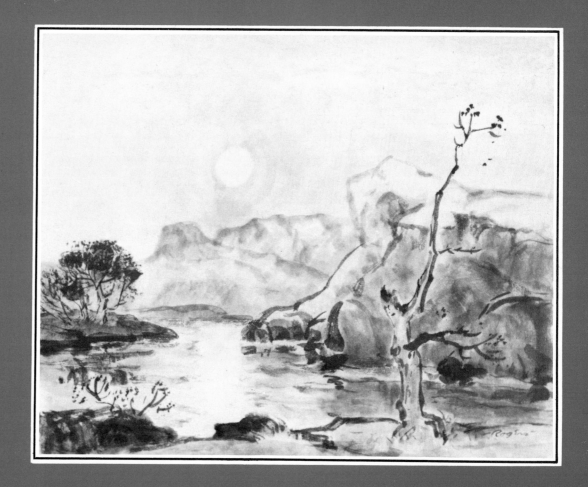

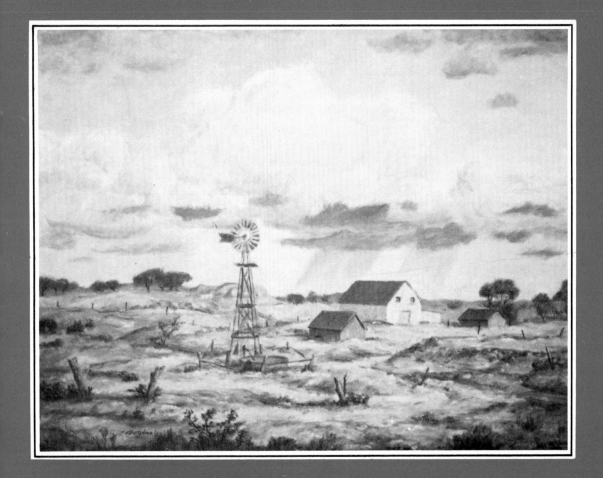

PASSING SHOWER

A tiny rain cloud
 Spoke softly in the distance...
Spoke a foreign tongue.

WINDY DAY

Wildly racing leaves
 Ride the breath of the southwinds
On autumn's last day.

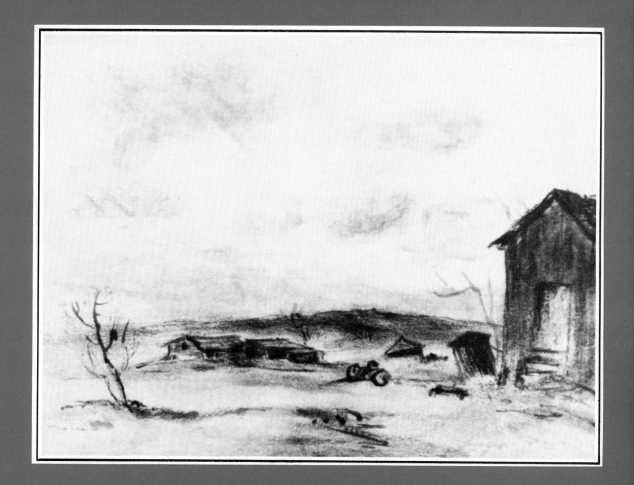

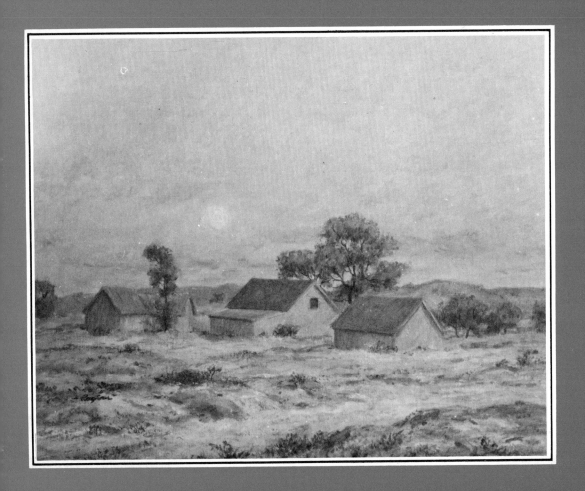

FULL SUMMER MOON

No full autumn moon
 Would dare forecast winter's cold
Till chill frost abound.

PAST SUMMER'S END

Do not fret, last leaves . . .
　　　Yours has been a wild delight
Throughout the summer.

126

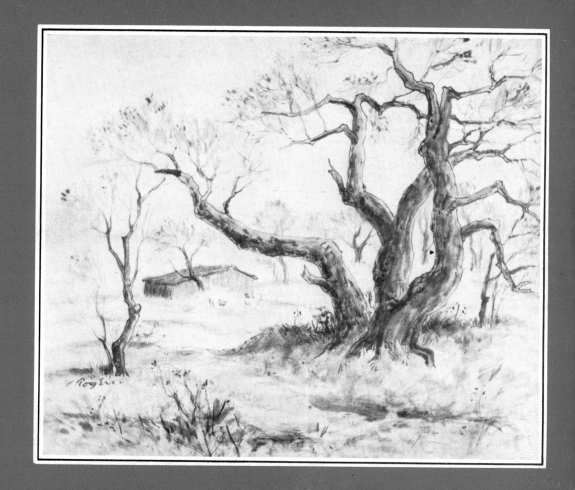

OTHER BOOKS OF INTEREST FROM CELESTIAL ARTS

THE ESSENCE OF ALAN WATTS. The basic philosophy of Alan Watts in nine illustrated volumes. Now available:
GOD. 64 pages, paper, $3.95
MEDITATION. 64 pages, paper, $3.95
NOTHINGNESS. 64 pages, paper, $3.95
TIME. 64 pages, paper, $3.95
DEATH. 64 pages, paper, $3.95
THE NATURE OF MAN. 64 pages, paper, $3.95
WILL I THINK OF YOU? Leonard Nimoy's warm and compelling sequel to You & I. 96 pages, paper, $3.95
THE HUMANNESS OF YOU, Vol. I & II. Walt Rinder's philosophy rendered in his own words and photos. Each: 64 pages, paper, $2.95
MY DEAREST FRIEND. The compassion and sensitivity that marked Walter Rinder's previous works are displayed again in this beautiful new volume. 64 pages, paper, $2.95
ONLY ONE TODAY. Walter Rinder's widely acclaimed style is again apparent in this beautifully illustrated poem. 64 pages, paper, $2.95
THE HEALING MIND by Dr. Irving Oyle. A noted physician describes what is known about the mysterious ability of the mind to heal the body. 128 pages, paper, $4.95
I WANT TO BE USED not abused by Ed Branch. How to adapt to the demands of others and gain more pleasure from relationships. 80 pages, paper, $2.95
INWARD JOURNEY Art as Therapy for You by Margaret Keyes. A therapist demonstrates how anyone can use art as a healing device. 128 pages, paper, $4.95
PLEASE TRUST ME by James Vaughan. A simple, illustrated book of poetry about the quality too often lacking in our experiences...Trust. 64 pages, paper, $2.95

LOVE IS AN ATTITUDE. The world-famous book of poetry and photographs by Walter Rinder. 128 pages, cloth, $7.95; paper, $3.95
THIS TIME CALLED LIFE. Poetry and photography by Walter Rinder. 160 pages, cloth, $7.95, paper, $3.95
SPECTRUM OF LOVE. Walter Rinder's remarkable love poem with magnificently enhancing drawings by David Mitchell. 64 pages, cloth, $7.95; paper, $2.95
GROWING TOGETHER. George and Donni Betts' poetry with photographs by Robert Scales. 128 pages, paper, $3.95
VISIONS OF YOU. Poems by George Betts, with photographs by Robert Scales. 128 pages, paper, $3.95
MY GIFT TO YOU. New poems by George Betts with photographs by Robert Scales. 128 pages, paper, $3.95
YOU & I. Leonard Nimoy, the distinguished actor, blends his poetry and photography into a beautiful love story. 128 pages, cloth, $7.95; paper, $3.95
I AM. Concepts of awareness in poetic form by Michael Grinder. Illustrated in color. 64 pages, paper, $2.95
GAMES STUDENTS PLAY (And what to do about them.) A Study of Transactional Analysis in schools by Kenneth Ernst. 128 pages, cloth, $7.95; paper, $3.95
A GUIDE FOR SINGLE PARENTS (Transactional Analysis for People in Crisis.) T.A. for single parents by Kathryn Hallett. 128 pages, cloth, $7.95; paper, $3.95
THE PASSIONATE MIND (A Manual for Living Creatively with One's Self.) Guidance and understanding from Joel Kramer. 128 pages, paper, $3.95